Low Budget Shooting

Cyrill Harnischmacher

Low Budget
Shooting

Do It Yourself Solutions to Professional Photo Gear

rockynook

Editor: Gerhard Rossbach · Translation: Christina Schulz · Copyeditors: Sarah Dixon, Joan Dixon
Layout and Type: Cyrill Harnischmacher · Cover Design: Helmut Kraus, www.exclam.de
Printer: Friesens Corporation, Altona, Canada · Printed in Canada · (3rd Printing, May 2010)

ISBN 978-1-933952-10-9

1st Edition
© 2007 by Rocky Nook Inc.
26 West Mission Street Ste 3
Santa Barbara, CA 93101
www.rockynook.com

First published under the title "lowbudget shooting" · © Cyrill Harnischmacher, Germany 2005

Library of Congress Cataloging-in-Publication Data

Harnischmacher, Cyrill.
 [Lowbudgetshooting. English.]
Low budget shooting : do it yourself solutions to professional photo gear /
Cyrill Harnischmacher. -- 1st ed.
 p. cm.
ISBN 978-1-933952-10-9 (alk. paper)
1. Photography--Equipment and supplies--Design and construction--
Amateurs' manuals. 2. Do-it-yourself work. I. Title.
TR196.H3713 2008
771--dc22

2008006841

My thanks go to Urte, Tabea, Jona, Ingrid, Andreas, Bettina, Charlie and to all those who have contributed to this book one way or another.

Introduction

The success of digital cameras has made photography much easier. Almost everything is automatically controlled except for the choice of subject. With digital cameras the results are immediately available, and the sensor saves all relevant image data, such as aperture, ISO, and shutter speed. This information can be used at a later time to recreate the shooting environment. These features are ideal for learning. However, all these automatic and program settings are useless in producing great images if the lighting is not good. This can be an insurmountable hurdle for many beginners. The entry into professional lighting technology is not cheap and can quickly exceed the available budget. Many amateurs simply wish to try new techniques and learn through experimentation without a large financial investment; it is in this pursuit that this book should prove helpful. Assuming you have some basic craftsmanship, you can build gear with affordable materials that rivals professional equipment. Even if you later choose to switch to a studio strobe system, you will still value many of the resources presented in these pages. Furthermore, tabletop photography often requires a talent for improvisation and unconventional solutions.

Is it worth the time and effort to build your own equipment? Definitely yes! Aside from the financial aspects, your study of lighting techniques is significantly more meaningful when using homemade gear than when using ready-made equipment. With personal involvement, you tend to question the results more critically, and thus you tend to move through the learning curve faster.

Please do not view this book as a mere collection of building instructions, but rather as an inspiration to develop your own gear. This is the reason why you will not find specific measurements in the instructions. The size and shape of the equipment should conform to your specific photographic needs.

This book is for anyone who wants to learn how to take better pictures with their camera; whether it is to document special collections, to develop in-house product catalogs, to create perfect layout pictures for graphic design, to work creatively with lighting, or to simply find a way into the depths of photography.

Much success and "good light".

Contents

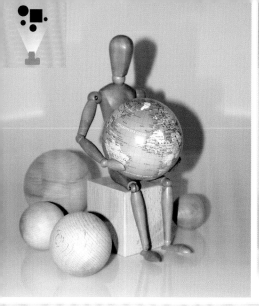

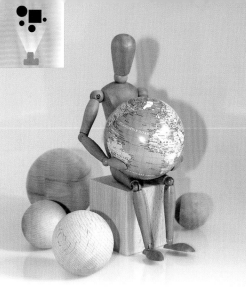

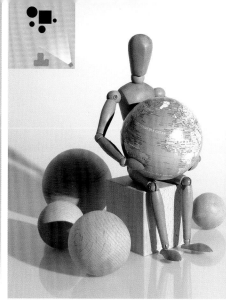

▲ **Internal Camera Flash:**
Not convincing. In addition, the flash is much too weak to ensure a great enough depth of field.

▲ **Rear Curtain Internal Flash: (Fill-in Flash)**
Slightly better with the incorporation of natural light, but the shadows running in two directions are distracting.

▲ **Off-Camera Flash:**
The shadows are more natural, but very hard. However, the external flash unit is much stronger and allows for a greater depth of field.

▼ **Off-Camera Flash and Diffuser:**
Beautiful, soft light without any distracting reflections on the shiny surface of the globe.

▼ **Big Softbox:**
Almost perfect. The balls look round; only the shadows are still a little dark.

▼ **Big Softbox and White Cardboard Reflector:** Now everything is perfect. This image was taken with only one external flash unit.

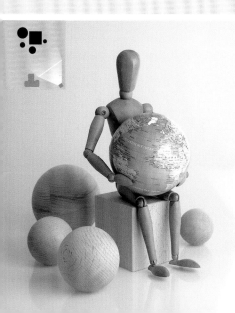

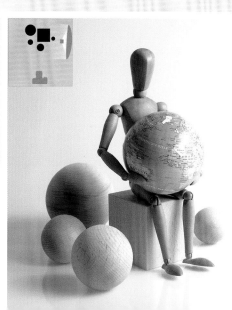

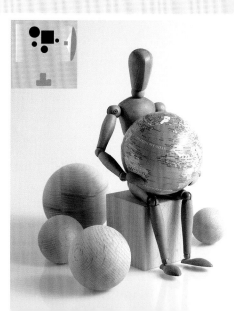

Soft Light

Whether in portraits or tabletop photography, hard shadows are often distracting. However, with a little effort you can produce much softer light and shadows. This does not necessarily mean investing in an expensive studio strobe lighting system. Simply by the correct placement of flash units and softening devices, you can achieve a significantly more natural looking light.

The images on the left page were all taken with only one external flash unit. However, you will need to have a synch cord or a hot-shoe adapter to be able to use your flash off-camera. Alternatively, you can control an external flash in connection with a slave unit by means of an internal camera flash or infrared flash. If you use the internal flash, you will also have to consider its effect on the subject.

Generally, some light intensity will be lost when using diffusers, softboxes, or reflectors. You can make up for this disadvantage by increasing the light sensitivity on your camera (e.g., by changing the ISO from 100 to 200). In our example, the background consists of an imaging table with a seamless backdrop of a slightly reflective Plexiglas surface. In the following chapters we will look at how to build this setup, along with other equipment.

You do not need expensive strobe lighting. You can achieve great results by controlling the lighting separately with a normal flash unit, using a few accessories, and adding a little know-how.

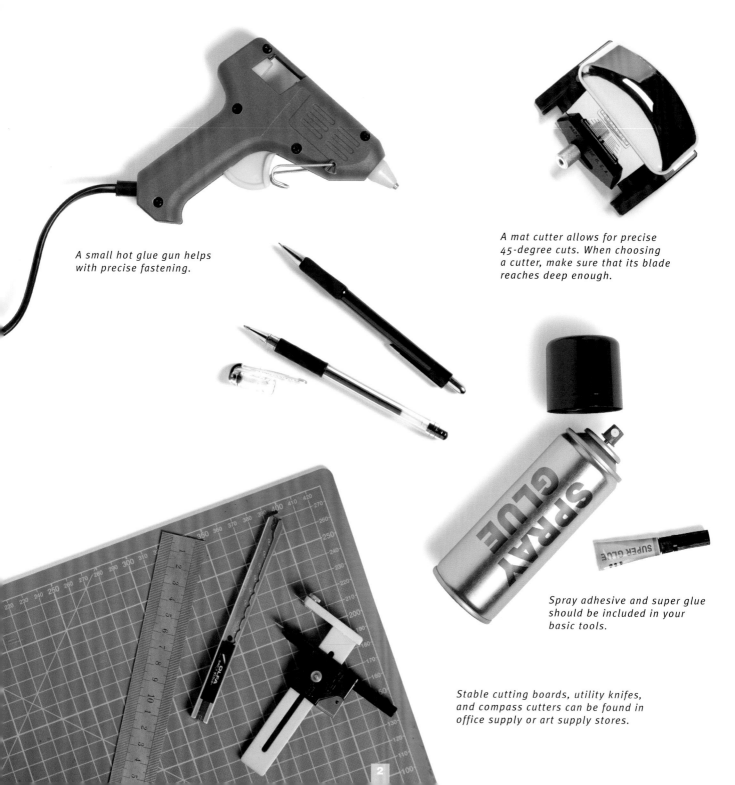

A small hot glue gun helps with precise fastening.

A mat cutter allows for precise 45-degree cuts. When choosing a cutter, make sure that its blade reaches deep enough.

Spray adhesive and super glue should be included in your basic tools.

Stable cutting boards, utility knifes, and compass cutters can be found in office supply or art supply stores.

The Right Tools

In order to build your own studio equipment, it is important to start out with some basic tools. Because you most likely already own many of the necessary tools, the shopping list should be relatively short. A metal ruler, a utility knife, and a stable cutting board are usually sufficient for most projects. In some cases, you will need a drill, as well as a screwdriver, metal saw, and riveter. In addition, you should have sandpaper, instant glue, and a collection of several types of tape. Spray glue is best suited to attach reflecting foil to large panel areas in softboxes. In the beginning, it might take some time to get used to a 45-degree mat cutter. Therefore, it is best to make a few test cuts before getting started on an actual project. In general, no prior experience is necessary.

Before you begin any project, go through your checklist. Do you have all the necessary materials and tools? It has been my experience that the glue usually runs out just after the stores close, and nothing is more frustrating than having to postpone a project just before it is completed.

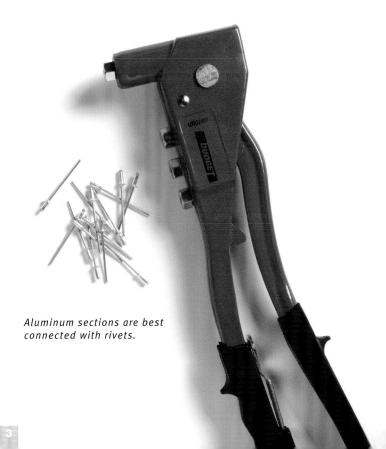

Always think about your own safety. A good utility knife will cut your fingers like butter. Therefore, keep band-aids in reach, just in case something goes wrong.

Aluminum sections are best connected with rivets.

Choosing Materials

In retail stores you can find a multitude of different materials that satisfy the most important requirements for building your own photography equipment; stable, easy to use, and as lightweight as possible. Each material has its own special qualities. Take into consideration the inherent characteristics of the materials. For example, how does the material react when being bent? As a result, you will create objects that are harmonious in form and function, and also look aesthetically pleasing.

A word of caution: Many of the materials described in this book are flammable. Due to the extreme heat generated by incandescent and halogen lights, the danger of fire is very high.

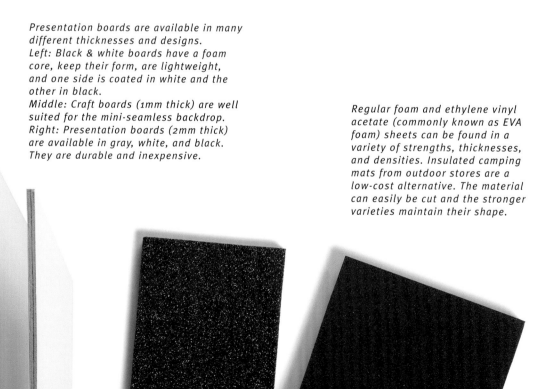

Presentation boards are available in many different thicknesses and designs.
Left: Black & white boards have a foam core, keep their form, are lightweight, and one side is coated in white and the other in black.
Middle: Craft boards (1mm thick) are well suited for the mini-seamless backdrop.
Right: Presentation boards (2mm thick) are available in gray, white, and black. They are durable and inexpensive.

Regular foam and ethylene vinyl acetate (commonly known as EVA foam) sheets can be found in a variety of strengths, thicknesses, and densities. Insulated camping mats from outdoor stores are a low-cost alternative. The material can easily be cut and the stronger varieties maintain their shape.

Connectors can easily be cut from tubing.

Ripstop nylon is great for building light tents and diffusers. It is generally purchased by the foot.

Many connectors and end caps can be found in kite building supply shops or websites.

White Plexiglas sheets are available not only in various strengths, but also in various transparencies. (If your local home improvement or glass shop carries only clear Plexiglas, you can spray one side with a semi-translucent, matte coating). The acrylic glass satine is especially interesting. With its slightly rough surface, it is ideal for both small and large diffusers. It is easy to cut with a utility knife and serves as a good "roof" for a small light tent. Backlit film or Mylar, usually available at graphic and drafting supply stores, are thin plastic sheets excellent for diffusing light.

Aluminum rods can be found in most hardware stores. Fiberglass rods are extremely light and flexible

An emergency blanket from a first-aid kit makes for a great reflective surface. These materials are extremely lightweight and highly reflective, and are great for lining softboxes, as well as for building light reflectors.

Overview of Useful Helpers:

The importance of accessories should not be under-estimated. These small helpers often transform work into a pleasure. You should keep them sorted and handy, for example, in a wheeled storage bin, because you will constantly need them to attach, tape, clamp, or raise objects. A right angle viewfinder [16] is

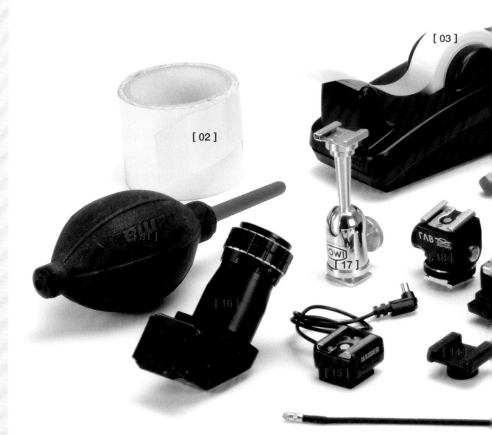

Small Helpers

especially useful in tabletop photography. It not only saves you from backaches, but also opens up completely new views and perspectives. When you buy one, make sure that it shows the image right side up. If you work with several flash units you should take a look at the flash slave attached to the synch cord [12]. Using an extension cord, you can place it into the light, even though the flash unit itself is placed further away; otherwise, a normal flash slave would lie in the shadow, for example, in a larger softbox.

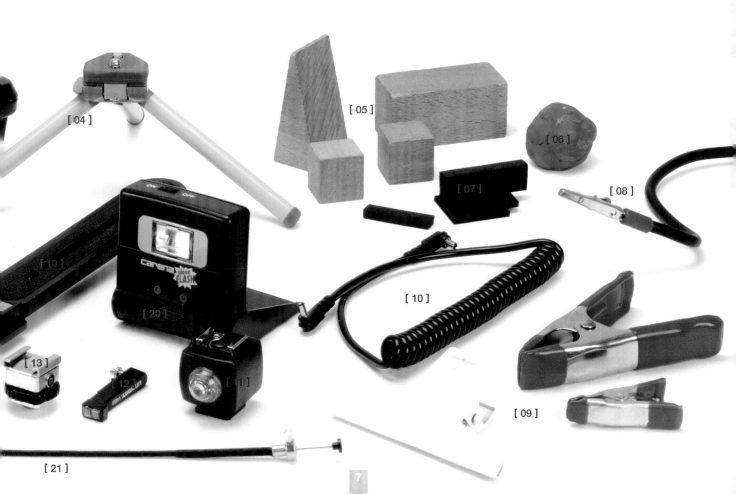

The Size of the Studio

Through the use of three examples, I would like to show you different possibilities of how to design your home studio, from the mini studio to the mobile studio, as well as a complete tabletop studio solution. But, first the question: What do you want to photograph? If you generally work with closeup photography, your requirements regarding light and space are completely different than with still life and product photography. A small attachable 8 x 8 inch softbox gives very nice, soft light for the detail of a watch. However, if you want to illuminate a flower arrangement with even and soft light, you need much larger light surfaces.

The second question is: How much space do you have available? Careful planning is essential, especially if you do not have a separate room available and always have to set up and disassemble your "studio." Your family or partner is more likely to accept a permanent studio location where you always work, over constantly "getting in the way" at home. Having a mobile solution brings additional advantages. Weather permitting, you can move to the balcony or garden and use natural lighting that no studio can offer.

▶ *Appealing results can be produced even with minimal expenditure. A mini-seamless backdrop made from cardboard, an off-camera flash, and an attachable diffuser are all that is needed to get started. However, your photographic options will be somewhat limited.*

▶ *Whether on your kitchen table or in your living room, this mobile studio is as quickly assembled as it is put away. The seamless backdrop also consists of cardboard, but black velour paper has been glued to one side. This paper absorbs a large portion of light and thus allows for a deep black background without distracting light reflections.*

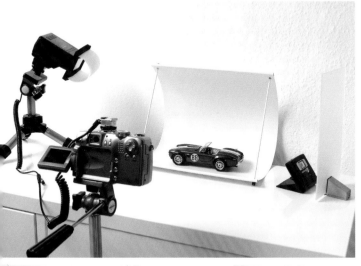

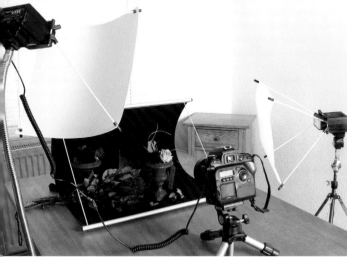

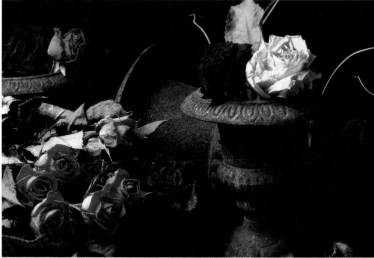

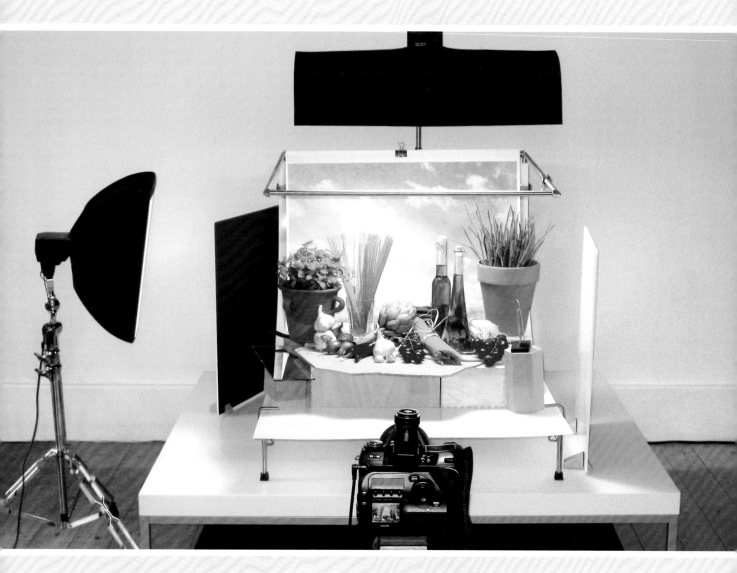

▶ *If you have a separate room available, your options naturally increase. As a base you can use the imaging table described in the following pages. Having a lot of space to arrange and align your lights allows for more freedom when working.*

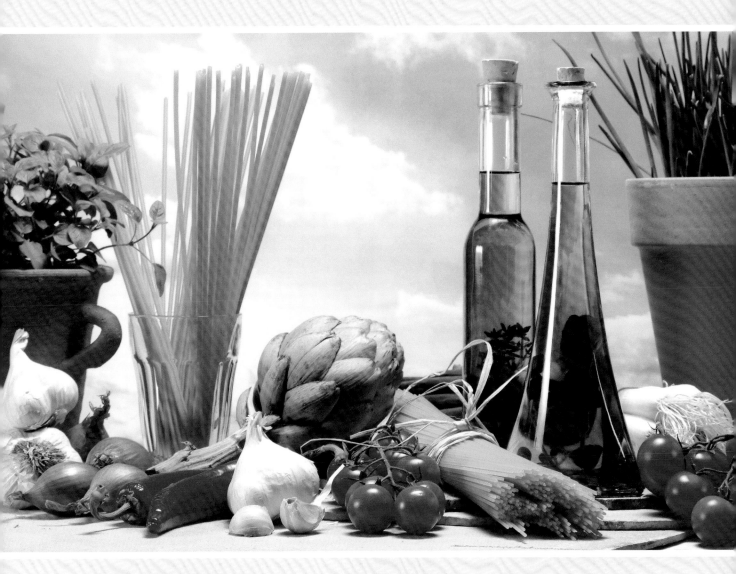

The softbox on the left page was attached to an instrument stand, and the overhead strip-light was attached to a microphone stand with a boom. Reflectors and mirrors ensure that good lighting is produced in the shadow areas.

Backgrounds

In many cases, the appropriate background creates the mood of the image. You can be collecting your backgrounds anytime, since interesting backgrounds can be found almost anywhere; at swap meets, on a walk, or while on vacation. Some materials, such as artificial snow, can be found in stage lighting supply stores, and perforated metal sheets and sand can be found in home improvement stores. However, you will come across most suitable decorative objects in your day-to-day life – you only have to notice them.

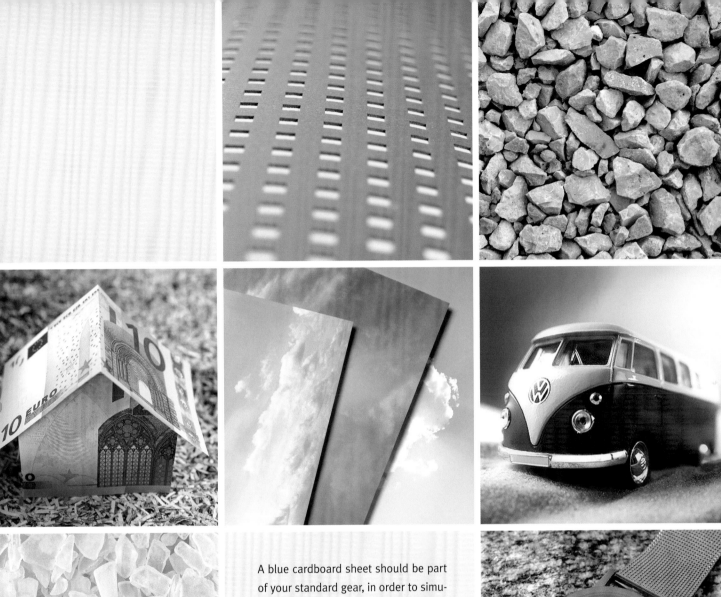

A blue cardboard sheet should be part of your standard gear, in order to simulate a sky in your studio. Better yet is a collection of images of different types of skies. Print them as large as possible on your inkjet printer, and they will allow you to create outdoor images even in rainy weather.

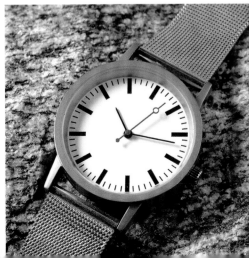

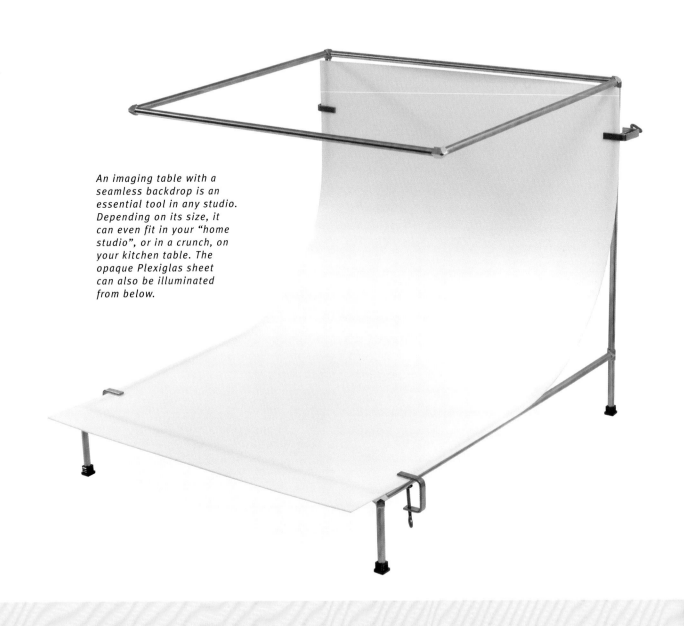

An imaging table with a seamless backdrop is an essential tool in any studio. Depending on its size, it can even fit in your "home studio", or in a crunch, on your kitchen table. The opaque Plexiglas sheet can also be illuminated from below.

The Imaging Table

This is where it's happening: The photographing of most objects takes place on an imaging table. Its size depends on the available space and on the size of the objects being photographed. Both of these factors should be considered when planning your table. It is a good idea to start with a base of approximately 28 x 30 inches and a total height of approximately 24 inches. (These are the measurements used in the building instructions.) Another thing to consider is the strength and stability of your imaging table. The bend in the Plexiglas sheet creates a significant force on the metal frame structure. In addition, the upper boom needs to be strong enough to support a flash, a diffuser, or other hanging decorations without sagging.

The first step is to obtain the materials. Rods and fittings can be found in hardware stores. The available connectors range from elbows to T-joints. The metal rods (curtain rods) used here came from a home improvement store. This option is not only more enticing because of the low price, but also gives you more choices regarding lengths. The Plexiglas sheet can also be bought at a home improvement store, a glass store, or it may be ordered via the Internet (some places only carry clear Plexiglas sheets – in this case you can coat it with a matte spray to get a semi-translucent opacity). It should not be thicker than 1/16". In addition to being less expensive, thinner material is less stiff and easier to light from below. Larger Plexiglas sheets can be cut to size by scoring the sheet with a utility knife a few times and then breaking it along the scored line. To attach the sheet to the metal frame, use c-clamps from the hardware store.

The rods can be cut to size with a normal metal saw, and after cutting, be sure to carefully file down the sharp edges. You may also want to use some epoxy glue in the connectors during assembly so that the rods will not come loose over time.

◀ Metal binder clips from the office can hold additional accessories. For example, these clips can be used to hang objects with nylon threads, without the danger of the objects slipping.

▼ Continuous backgrounds without a distracting horizon line can only be accomplished with a seamless backdrop.

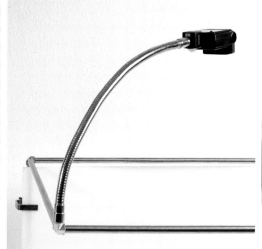

▶ An attached gooseneck extension is shown here with a small flash unit. You can also attach reflectors, mirrors, etc.

◀ The fittings from the hardware store are also available as elbows, T-joints, etc.

▶ You can use illumination from below to create interesting effects in your images.

Fasten the Plexiglas sheet with c-clamps – and it's finished. Additionally, you could attach a gooseneck extension on the upper boom that is useful for positioning small off-camera flash units (tip: use a cheap gooseneck lamp from the home improvement store and modify it for your photographic needs). The necessary screw with a tripod mount and the accessory flash shoe can be purchased at larger photographic specialty stores or through the Internet. Metal binder clips have proven to be of value for affixing additional elements, such as colored foil or hanging objects. While choosing the right location for your imaging table, be aware that the color of the table, such as the wooden surface of a desk, can show through the opaque Plexiglas and influence the shadows of the object you are photographing. You can easily prevent this effect if you set a white sheet of cardboard underneath the imaging table, or you can use this knowledge creatively, for example, by using colored foil or paper for special effects.

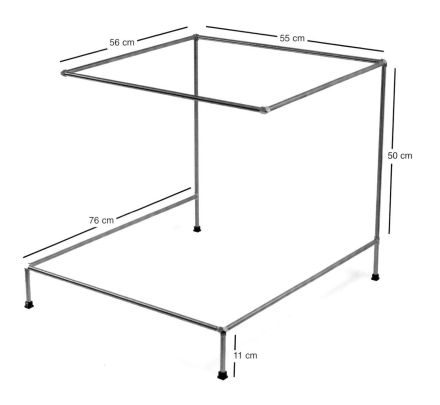

MATERIALS:
- Metal rods
- Plexiglas sheet, translucent
- Fittings
- Gooseneck extension
- Screw with tripod mount
- Accessory flash shoe

TOOLS:
- Metal saw
- Metal ruler
- Utility knife
- Epoxy glue
- Sand paper or metal file

SOURCES FOR MATERIALS:
- Home improvement store (rods / glue / gooseneck lamps, Plexiglas)
- Hardware store (fittings)
- Photography store (screw / hot shoe)
- Internet

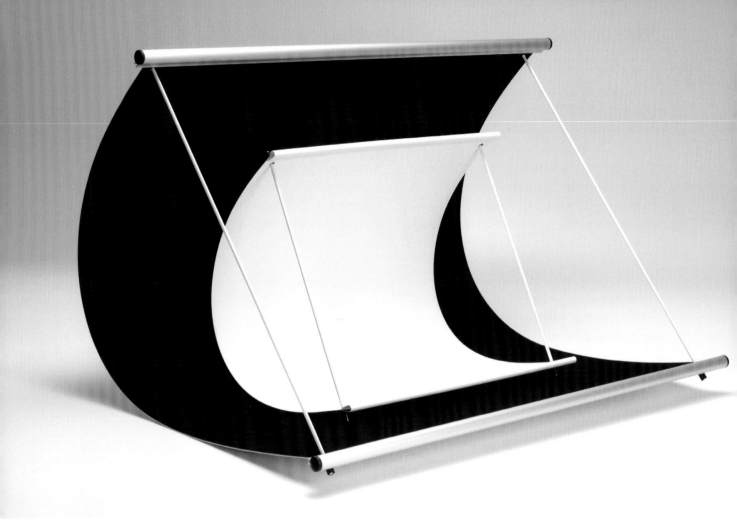

▲ *Assembly time: approximately 10 minutes.*

◄ *Fiberglass rods maintain the shape of the seamless backdrop while a poster hanging rail gives stability on each end of the backdrop.*

Mini-Seamless Backdrop

The purpose of a seamless backdrop is to create a continuous transition between the horizontal and the vertical background surfaces. If your working space is small, such as on your kitchen table, the seamless backdrop needs to be easily set up, as well as quickly disassembled. The required strength of the materials depends on the size of the backdrop. The small cardboard version (size approximately 12 x 16 inches) with a paper weight of 300g/m2 is sufficient, whereas the larger version (20 x 28 inches) requires a material that is more stable; 1/32" (1mm) thick presentation cardboard is ideal. Additionally, black velour paper was glued with spray glue to one side of the backdrop, so that a dual background variation is available simply by flipping over the cardboard and reattaching the rods. To connect the fiberglass rods, make holes in the corner of the cardboard with a regular hole-punch.

Rubber tubes attached to the ends of the fiberglass rods prevent the cardboard from sliding off the rods, and different placements of the tubes can change the bend in the backdrop. Clipping on poster hanging rails stabilizes the front edges of the cardboard. Both plastic and aluminum rails are acceptable depending on your preference.

Poster hanging rails are available in different versions made of plastic and aluminum.

MATERIALS:
- Fiberglass rods
- Rubber tubing
- Presentation cardboard
- Black velour paper

TOOLS:
- Utility knife
- Scissors
- Hole punch
- Small metal saw

SOURCES FOR MATERIALS:
- Art and crafts supply store (cardboard, velour paper)
- Kite building store (rods)
- Home improvement store (rubber tubing)

Small Light Tent

Shiny surfaces, reflective objects, and continuous illumination with soft shadows are only a few of the requirements in product photography – a case for the light tent. Just as with the imaging table, the base material is a white Plexiglas sheet. Added are two fiberglass rods with fitting end caps from the kite building store and a translucent plastic sheet. Drill a hole into each corner of the Plexiglas plate to attach the fiberglass rods. After you cut the plastic sheet (backlit film or Mylar) to size, cut a round hole in the center, through which you can take pictures from above. The size of the hole should match the lens you will be using. Fasten the rods to the plastic sheet with tape and bend it so that a curved "roof" is formed. At each end, stick the rods into the holes of the Plexiglas sheet and attach the end caps. For illumination, you can use one or more off-camera flash units.

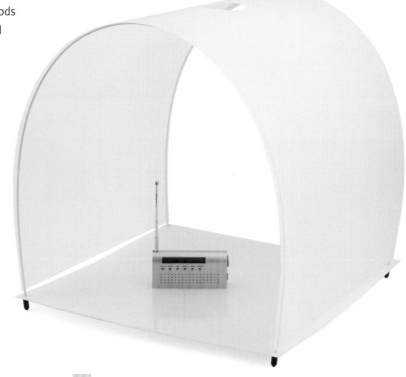

MATERIALS:
- Fiberglass rods
- Backlit film or Mylar
- Stoppers (end-caps) for rods
- White cardboard or Plexiglas

TOOLS:
- Metal ruler
- Utility knife
- Compass cutter
- Screwdriver/drill
- Transparent tape

SOURCES FOR MATERIALS:
- Kite building store (rods / end caps)
- Office/art supply store (cardboard)
- Graphic or drafting supply store (Plexiglas / backlit film)

▲ The top opening should not be smaller than the diameter of your lens.

▲ Attach the rods with transparent tape to the plastic sheet before bending the "roof".

▲ Stick the ends of the rods into the drilled holes and secure them with the end caps.

▼ The opening in the roof of the light tent not only allows you to take photographs from above, it also allows you to drop things from above into the scene.

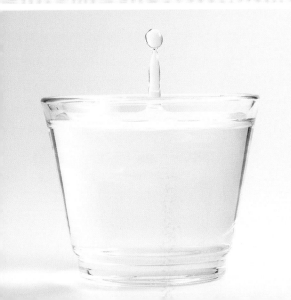

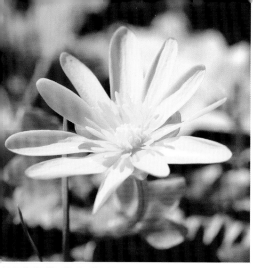

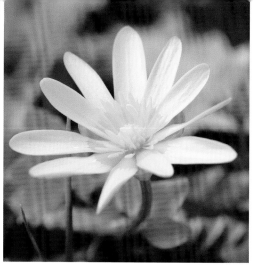

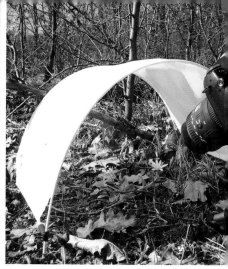

▲ In direct sunlight, the highlights are often exaggerated and the harsh shadows are distracting

▲ The outdoor light tent creates a pleasant, soft lighting, which is complimentary to the subject.

▲ Simply stretched above the subject, this light tent is quickly set up.

▼ Off-camera flash: Some important details of the subject are cast in shadow and are hardly recognizable.

▼ Off-camera flash with light tent: The light is spread much more evenly, and overall, the mood seems very natural.

▼ The materials from the kite building store allow the tent to be set up and packed away quickly. Simply plug the rods into the fittings – and you're done.

Outdoor Light Tent

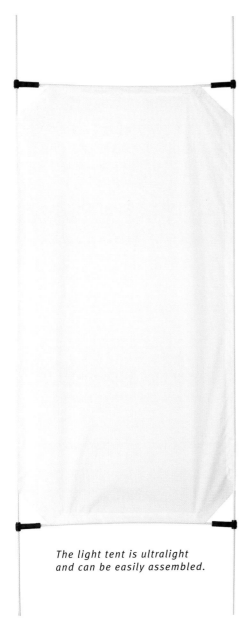

The light tent is ultralight and can be easily assembled.

It can be useful to employ a light tent, even while photographing in nature. If the bright sunlight renders the contrast in your image too high, you are left with the choice of blown-out highlights or dark shadows. In order to build the light tent, you need ripstop nylon, fiberglass rods, and fittings from the kite-building store. Working with the nylon material is simple (see Travel Diffuser). The light tent introduced here is made especially for closeup photography and is the smallest useful size. Size is limited only by the available material. While setting up your tent outdoors, you should first push the rods of one side securely into the ground, then bend it over the subject and push the other two rods into the ground on the other side. If your subject is large, you can also use as a diffuser or reflector by pushing only one side into the ground. Together with an off-camera flash, the light tent delivers natural and soft lighting.

MATERIALS:
- Fiberglass rods
- Fittings
- Ripstop nylon

TOOLS:
- Scissors
- Thin double-sided tape
- Sewing machine

SOURCES FOR MATERIALS:
- Kite building store (rods / fittings)
- Office supply store (tape)

The Big Light Cube

The light cube is significantly larger than the small light tent; therefore it is a good idea to think about the objects you want to photograph during the planning process. Take into consideration that the objects need to have enough distance from the sides (e.g., to include larger backgrounds), and that there should be enough space to set up lighting equipment.

You can construct a light box with a rectangular shape using different lengths of panels, which will allow you to use it horizontally or vertically. If you want to use the cube outside, you should make sure that the whole structure fits through your door and hallway. After deciding on the measurements, you begin by building the frame. The frame consists of

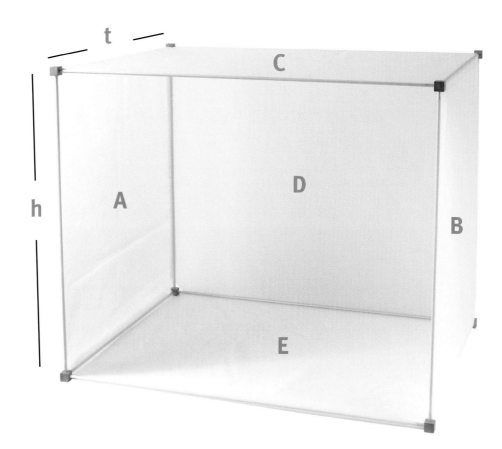

To photograph large objects without distracting reflections, the light cube needs to be of considerable size.

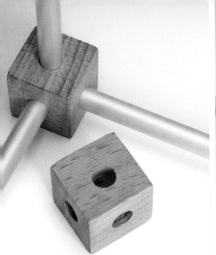

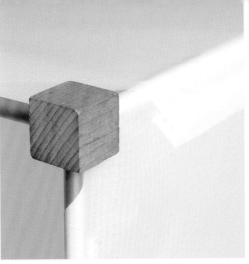

▲ Small wooden building blocks with drilled holes make ideal connectors.

▲ The flaps of pieces C, D and E are attached with transparent double-sided tape to the sides of A and B.

▲ Curtain hooks with clips hold the material for the background; a poster hanging rail gives the necessary stability to the panel.

aluminum rods (5/16" or 8 mm thick) and wooden building blocks, which serve as corner joints. When drilling the holes, it is useful to employ a stable drill rig; a vise clamp to hold the block works well, or a drill press is ideal. Once the rods are cut to the correct lengths and the sharp edges are filed smooth, you should test how well the rods fit into the joints by setting up the frame. If the aluminum rods are too loose, you can tape the ends with transparent tape. It is ideal if the rods fit snugly and can just barely be pushed into the holes.

Now the fabric can be cut to size. Measure the size of the individual spans on the assembled frame, and remember that the fabric between the pieces of C, D and E has to wrap around the rods as well. The flaps should be at least 2 inches wide, and will later be sewn around the rods. After cutting the fabric, assemble the whole cube for a test run. If all pieces still fit after this test, you can begin sewing. The sewing will be much easier if you first attach the flaps to the sides with thin double-sided tape. Only sew the flaps for the sides (A and B) and the front

The even distribution of light in the light cube is ideal for product photography.

◀ *You can create the appearance of a windowpane reflecting on shiny surfaces by simply hanging black cardboard with the desired cutouts. By using individual cardboard strips, you can precisely control the reflections and lighted edges on your subject.*

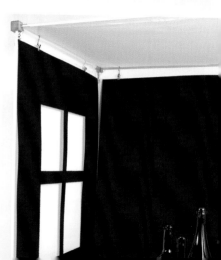

flaps top and bottom (the end pieces of C and E). All other flaps of C, D and E will be attached with double-sided tape (or Velcro, which is a good solution) on the sides of A and B after assembly. This way, the upper rods will be totally exposed, or will be only partially covered with cloth, giving access to the rod for attaching other items, e.g., a piece of cardboard for a seamless backdrop, reflectors, or similar items. The curtain hooks with clips can be found in a fabric store. A poster hanging rail can give added stability.

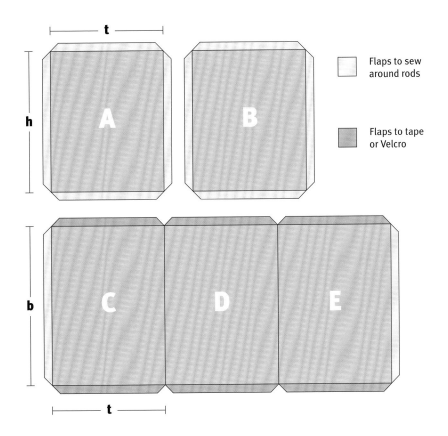

□ Flaps to sew around rods

▨ Flaps to tape or Velcro

MATERIALS:
- Aluminum rods
- Ripstop nylon
- Wooden building blocks
- Curtain hooks
- White or colored cardboard
- Tape or Velcro

WERKZEUG:
- Utility knife
- Scissors
- Drill (and clamp)
- Sewing machine
- Thin double-sided tape

MATERIALEINKAUF:
- Kite building store (ripstop nylon)
- Home improvement store (aluminum rods / wooden blocks)
- Fabric store (curtain hooks/Velcro)

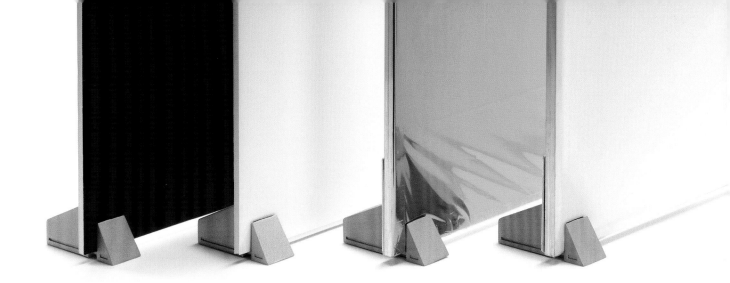

▲ Black cardboard is used to shade the subject and to avoid bounced light.

▲ A white reflector lightens up shadow areas.

▲ A golden reflector is good for warm, sunny light; a silver one provides cold, technical light

▲ A diffuser can be placed between the flash and the subject to distribute the light, which results in softer shadows and even illumination.

▼ Two diffusers, each with one flash, created the white reflections on the chrome surface.

▼ The four-sided aluminum rods are riveted to triangular aluminum plates on the corners to construct a very stable frame.

▼ Black cardboard placed close to the subject can help emphasize its contours and shapes.

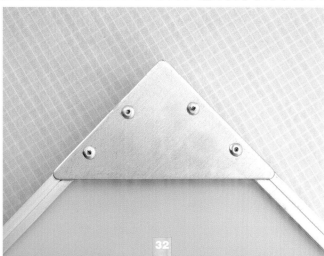

Reflectors and Diffusers

Just as the names imply, reflectors reflect light and diffusers diffuse light. They transform harsh shadows to appear softer and more diffused. Depending on the subject, you can use silver (cold, technical light), gold (warm light), or white reflectors (neutral light). Colored surfaces may also be used for interesting creative accents. It is easy to find black and white foam core presentation boards, which are matte black on one side and coated with white on the other. Because of the foam core, they are especially lightweight and can easily be cut to size. This is helpful in creating reflections on metal, glass, or other shiny surfaces with very small reflectors. You can also use white Styrofoam sheets or even regular cardboard. Glass shelf brackets are especially suited to give your reflectors a firm base. These brackets have the advantage of being adjustable to hold sheets of different thicknesses. This way you don't have to buy a separate set for each different type of reflector, as you can easily and quickly interchange them. To build your diffuser you will also need Mylar, (the same material used for the light tent), as well as 4-sided aluminum rods and triangular aluminum plates. Once these are riveted, you will have an extremely stable, yet still very thin frame. Use normal transparent tape to attach the Mylar to the frame.

Glass shelf brackets serve as sturdy bases for your reflectors.

MATERIALS:
- Aluminum rods
- Mylar
- Colored foil, emergency blanket
- Glass shelf brackets
- Foam core presentation board
- Tape

TOOLS:
- Metal saw
- Riveter
- Metal ruler
- Utility knife
- Scissors
- Sand paper or metal file
- Transparent tape

SOURCES FOR MATERIALS:
- Home improvement store (rods, tape, glass shelf brackets, emergency blanket)
- Art, craft or office store (colored foil, foam core presentation boards)

▲ Place the frame on the ripstop nylon and draw the outline of the reflector, including the flaps which will later house the rods.

▲ After cutting the fabric, temporarily attach it with tape and mark the seam.

▼ Affix the seams before sewing them. Transparent double-sided tape from a kite building shop works well and does not need to be removed after sewing.

▼ Taping the seams beforehand keeps the nylon from slipping while sewing. Slip the rod out of the taped flaps, and you are ready to sew.

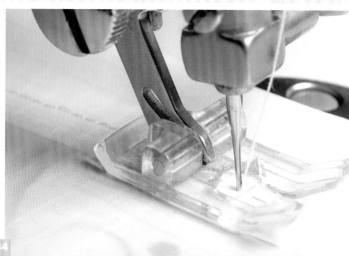

Travel Diffuser

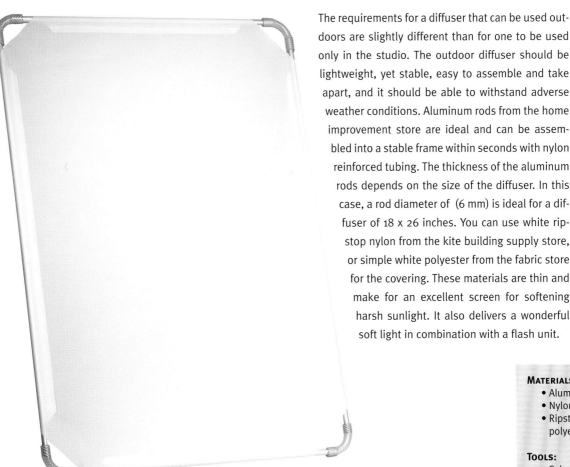

The requirements for a diffuser that can be used outdoors are slightly different than for one to be used only in the studio. The outdoor diffuser should be lightweight, yet stable, easy to assemble and take apart, and it should be able to withstand adverse weather conditions. Aluminum rods from the home improvement store are ideal and can be assembled into a stable frame within seconds with nylon reinforced tubing. The thickness of the aluminum rods depends on the size of the diffuser. In this case, a rod diameter of (6 mm) is ideal for a diffuser of 18 x 26 inches. You can use white ripstop nylon from the kite building supply store, or simple white polyester from the fabric store for the covering. These materials are thin and make for an excellent screen for softening harsh sunlight. It also delivers a wonderful soft light in combination with a flash unit.

This can be used as a diffuser or reflector, and can be completely disassembled. You can also sew yourself a carrying bag from the scraps of the fabric.

MATERIALS:
- Aluminum rods
- Nylon reinforced tubing
- Ripstop nylon or polyester fabric

TOOLS:
- Scissors
- Transparent double-sided tape
- Metal saw
- Metal file or sand paper
- Sewing machine

SOURCES FOR MATERIALS:
- Home improvement store (rods, nylon reinforced tubing)
- Kite building supply store (ripstop nylon, double-sided tape)

Ultra-light Reflector

Building your own ultra-light reflector is worthwhile, especially when every ounce counts. Thanks to the ultra-light materials, the reflector shown here, at a size of 24" x 24", barely weighs 80 grams, which is less than a bar of chocolate. In addition to the 1/8" diameter fiberglass rods and the 3-way end-joints from the kite-building store, you will need an emergency blanket which can be found in most first-aid kits, or metallic colored foil from the arts and crafts store. The outer rods in this example are 24 inches and the diagonal rods are 32 inches. Adding the diagonal rods makes the reflector more stable and also allows you to hold it in the middle with one hand. After assembling the frame, set it on top of the foil and cut out the shape of the reflector plus an additional 1 1/4" for the flaps. To enhance the diffusing effect of the reflector, crinkle the foil before attaching it with the transparent tape.

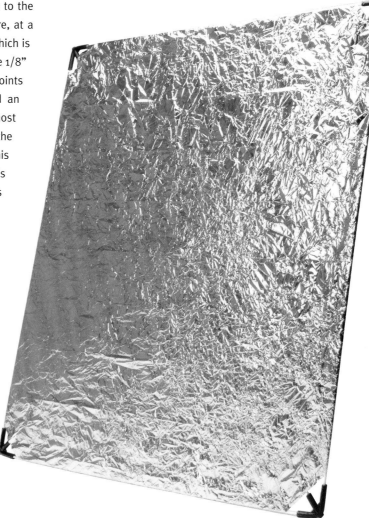

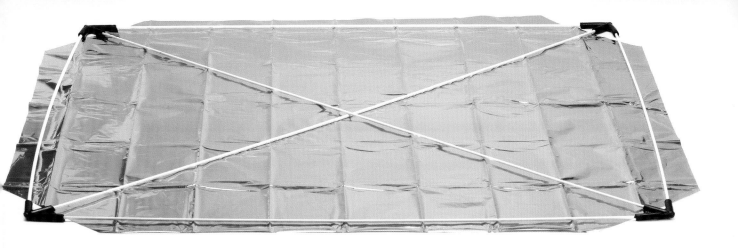

▲ The basic frame serves as a template for cutting the foil/emergency blanket.

▼ Turn over the flaps and attach them with transparent tape. The tape sticks well enough to the foil so that additional glue is not needed.

▼ "Let the sun shine." A gold foil reflector imitates sunlight even when it is overcast.

MATERIALS:
- Fiberglass rods, (3 mm)
- 3-way end-joints
- Emergency blanket or metallic foil

TOOLS:
- Scissors
- Utility knife
- Metal saw
- Transparent tape

SOURCES FOR MATERIALS:
- Kite building supply store (rods and connectors)
- Home improvement store (emergency blanket)
- Arts and crafts store (colored foils)

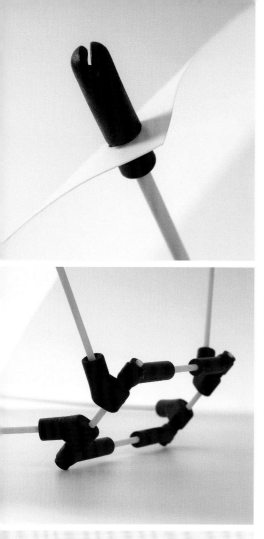

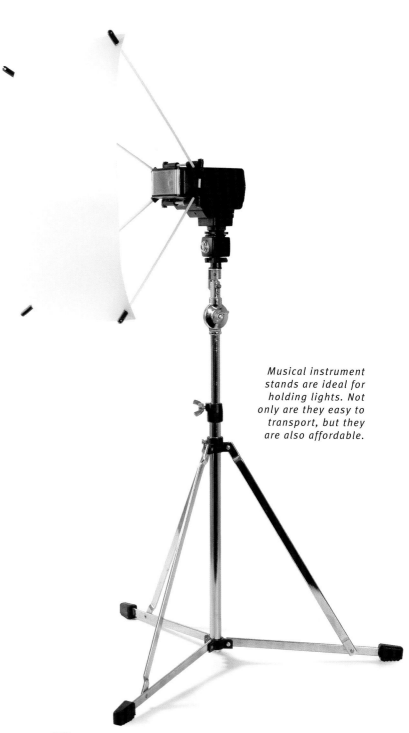

▲▲ Cut the end caps into 2 pieces, so that you can wedge the diffuser material in between them to prevent it from sliding.

▲ The diffuser frame can easily be adapted to different flash units by shifting the connectors.

Musical instrument stands are ideal for holding lights. Not only are they easy to transport, but they are also affordable.

Flash Mounted Diffuser Frame

Constructing a diffuser that can be mounted onto your flash is quick and simple. Kite building stores are ideal places to buy build-it-yourself materials. Everything can easily be modified with the tools you have at home, and the materials are affordable and extremely lightweight. Besides the fittings, fiberglass rods, and end caps, you only need a piece of 12" x 12" Mylar or backlit film. You can cut the 1/8" thick fiberglass rods with a small metal saw to the appropriate length of 10". Wrap a piece of tape around the ends of the rods to prevent them from splintering. The lengths of the rods for the mounting portion should match the size of your flash unit. Assemble the frame in such a way to ensure that all parts fit snugly. If any of the rods sit loosely in the fittings, you can tape them as well.

Use a normal hole punch to make holes in the plastic film. Then cut the end caps into 2 sections and push the cut rings onto the ends of the fiberglass rods. Next, attach the film and secure the ends of the rods with the caps. Simply place the finished diffuser frame onto the flash. The diffuser spreads the light from the flash and thus creates much softer shadows than with a flash alone. The quality of the light is similar to that of a small softbox. Be aware that you will have to open up an extra stop to compensate for the loss of light.

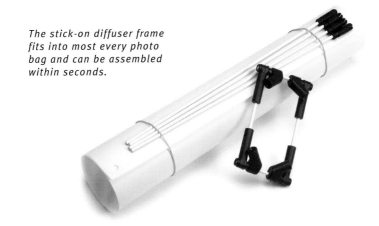

The stick-on diffuser frame fits into most every photo bag and can be assembled within seconds.

MATERIALS:
- Fiberglass rods
- End caps / fittings
- Mylar or backlit film

TOOLS:
- Utility knife
- Scissors
- Sand paper
- Transparent tape
- Hole punch

SOURCES FOR MATERIALS:
- Kite building supply store (rods, fittings, and end caps)
- Graphics or drafting supply stores (Mylar or backlit film)

Softboxes and Striplights

Not only should softboxes be part of the basic equipment in your studio, they can also be used outdoors for adding pleasant, soft lighting. The base material is black foam, to 3/8" (8-10 mm) thick, that is sometimes used in the manufacturing of insulation mats. When purchasing, be sure to look for a rigid version, which will maintain its form. Begin by drawing your basic shape onto the foam with a light marker, then cut it with a utility knife. The shape and size of the boxes primarily depend on the type of images you want to produce. For the square softbox illustrated here with a diffuser size of 12" x 12", you will need to start with a base of 20" x 20". The size of your flash will determine the size of the cutout in the center, as well as the length of the elastic band that will connect the softbox to the flash. Spray glue works well to attach metallic foil evenly onto the foam sheets (this will be the inner surface). To prevent gluing places that need to stay clean, cover them with removable tape when applying the glue. In order to get a lasting bond, cover the surfaces with the spray glue several times and let it sit for a short time before attaching. Only use spray glue in well-ventilated areas for obvious health reasons. After gluing the foil to the foam, use a glue gun to attach the elastic band. The elastic band is attached to the inside of the softbox on either side of the cutout in the center of the softbox (see photos on upper right of page 43 and lower right of page 46). Now, you can connect the pieces of the basic shape. Start by gluing the outer edges together in order to get the nicest possible seams, and keep working in roughly 4" increments. Hold the glued seams together for a while until the glue sets. When the base form is finished, measure the front opening and cut the diffuser panel from the Mylar to fit. Don't forget to leave 1/2 '' flaps on each side to glue the panel into the base form. To this end, apply extra strong double-sided tape (tape used for attaching mirrors works well) that can be purchased from a home improvement store. If you are inclined to develop your own softbox shapes, it is beneficial to build a miniature box from paper first. This way you can recognize potential problems in the shape before beginning the project.

MATERIALS:
- Foam sheets or insulation mats (very rigid)
- Emergency blanket or metallic foil
- Mylar or backlit film
- Elastic band

TOOLS:
- Spray glue
- Glue gun
- Utility knife
- French curve ruler
- Masking tape
- Strong double-sided tape

SOURCES FOR MATERIALS:
- Home improvement store (emergency blanket / glue)
- Art or drafting supply store (French curve ruler, Mylar)
- Outdoor sporting goods store (insulation mats)

▲ After cutting the base form, use tape to mask those places that should not be covered with spray glue.

▲ The inner covering consists of silver or gold metallic foil, or a combination of both.

▲ Attach the elastic band with a glue gun to the inside of the box.

▼ Use a glue gun to construct the sides of the box. Work only with roughly 4" increments when gluing, because the hot glue sets relatively fast.

▼ Score the flaps of the Mylar with a scoring tool (or use the back of a butter knife), bend them, and attach extra-strong double-sided tape.

▼ To conclude, set the Mylar diffuser into the box and attach the flaps. Now you are finished.

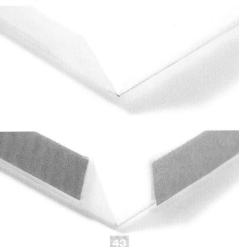

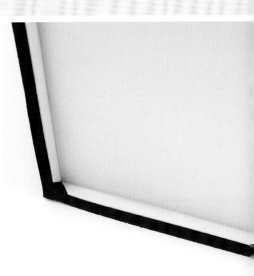

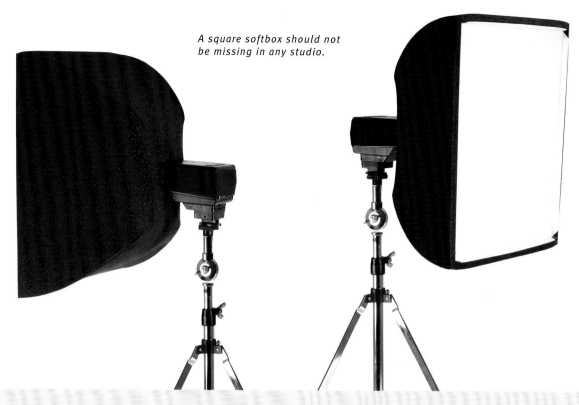

A square softbox should not be missing in any studio.

▼ *The shape of the square softbox consists of a single base sheet.*

▼ *Covering the inside of the box with silver-colored foil is useful for technical subjects for which a neutral lighting is important. Depending on the location of the softbox, the diffuser shows as a reflection in the subject.*

▼ *Mark the beginning and end points of the curve on your ruler to make it easy to replicate the same curve.*

Base Form

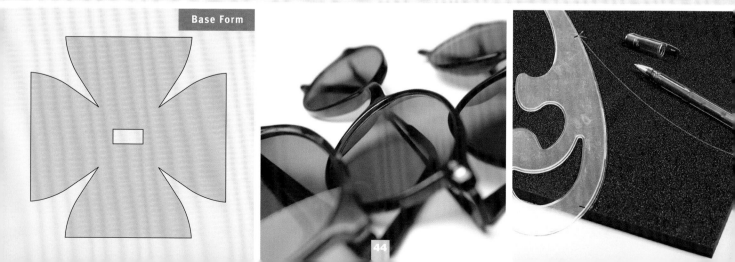

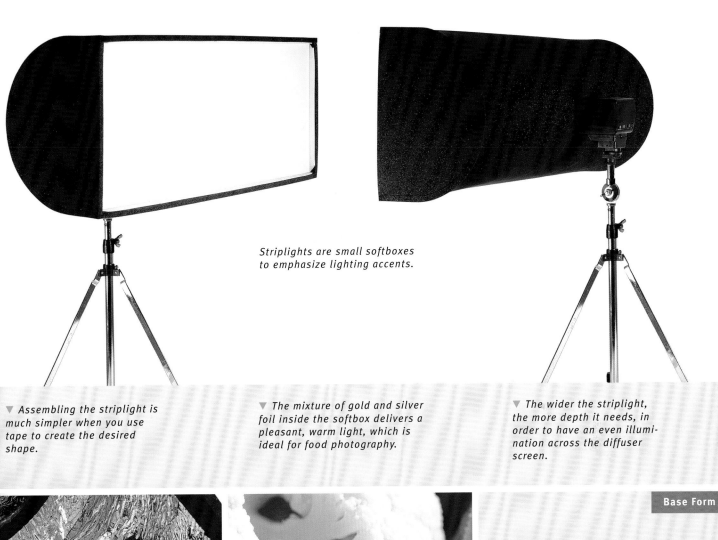

Striplights are small softboxes to emphasize lighting accents.

▼ Assembling the striplight is much simpler when you use tape to create the desired shape.

▼ The mixture of gold and silver foil inside the softbox delivers a pleasant, warm light, which is ideal for food photography.

▼ The wider the striplight, the more depth it needs, in order to have an even illumination across the diffuser screen.

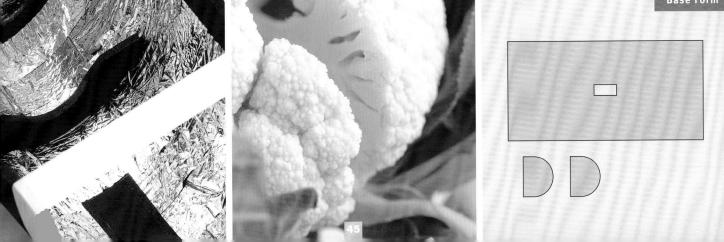

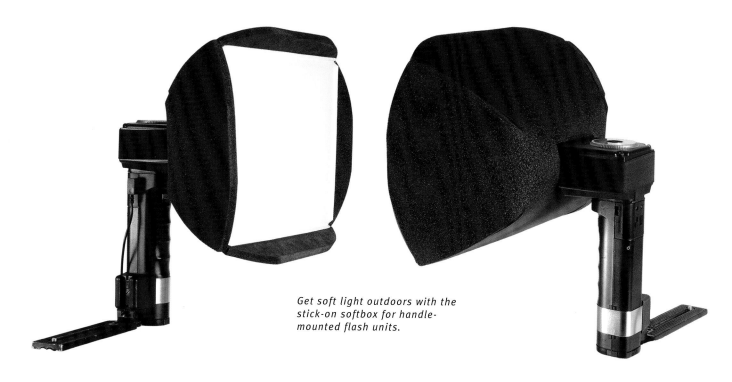

Get soft light outdoors with the stick-on softbox for handle-mounted flash units.

▼ The rounded sides create the integrated barn doors.

▼ Lined with gold foil, the soft-box provides a warm, natural lighting for portrait photography.

▼ The glued on elastic band attaches the softbox on to the flash unit.

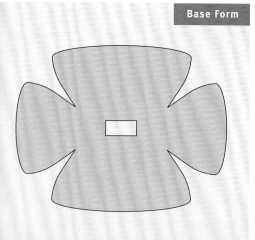

Base Form

46

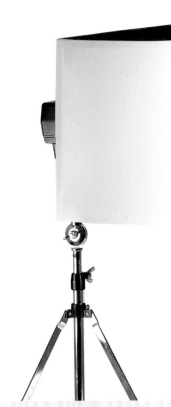

Let your imagination soar and develop your own softbox shapes.

▼ If you cannot control the output of your flash, you can lessen the intensity by using neutral density filter film in front of your softbox. You can also combine more than one layer of film.

▼ A box with a rounded diffuser panel distributes the light more softly and evenly than other soft-box shapes. Contrast this soft lighting effect with an off-camera flash without any diffusion.

▼ For larger circular cuts you will need a template, for example, a bowl or lid.

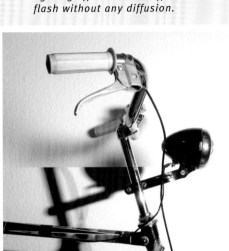

Soft Lighting To Go

When on the road you don't have to forego soft lighting. A small flash-mounted "travel diffuser" can significantly soften harsh flash lighting, and a mini-softbox can deliver even softer shadows. Additionally, if you move the flash off your camera (for example, onto a flash bracket), you can influence the direction of the shadows to a certain degree.

The material for the basic shape of these boxes is black EVA foam. It can easily be cut with a utility knife and glued together with instant glue. Another advantage is EVA foam's elasticity. When precisely cut, you can stick the softbox onto the flash unit without needing any other fastening device (such as the elastic used on the larger softboxes). The mini-softbox is also well-suited for a closeup studio. Because of their small size they can be positioned with ease, yet offer a huge lighting surface compared to the subject. There are no limitations to the possible shapes of the mini-softbox. The shapes illustrated in the studio section can easily be adapted to a smaller scale and vice versa.

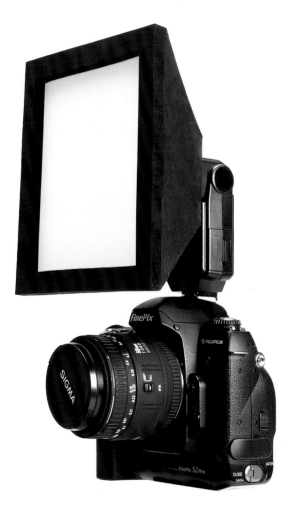

Softboxes made from EVA foam are extremely lightweight and therefore are ideal for use on the road.

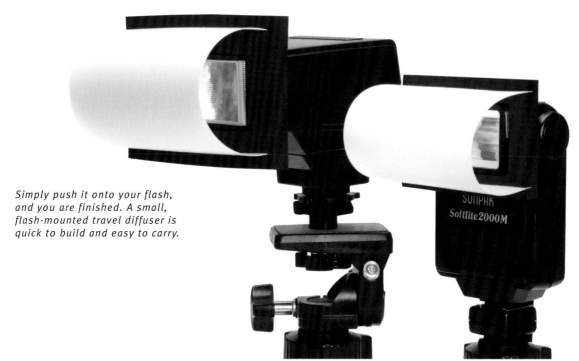

Simply push it onto your flash, and you are finished. A small, flash-mounted travel diffuser is quick to build and easy to carry.

In principle, the flash-mounted diffuser is nothing more than a piece of thin, curved Plexiglass. In order for the Plexiglass to be quickly and easily attached to the flash, a slip-on base is constructed. First cut a rectangular shape out of the 3/8'' EVA foam sheet. Next, cut a rectangular opening in the center that will fit onto your flash. Make a 1/8" deep cut along the upper and lower edges to insert the diffuser panel, and then attach it with a few drops of instant glue. It's that simple!

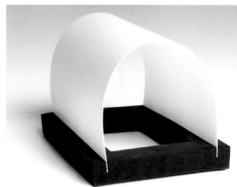

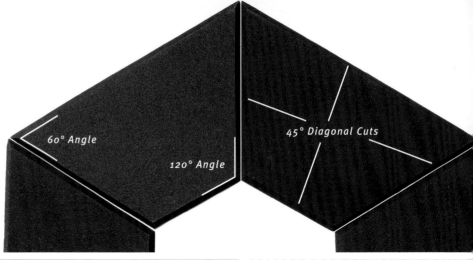

60° Angle

120° Angle

45° Diagonal Cuts

▲ You can make precise and clean 45° cuts with a mat cutter.

▶ You can influence the color of the softbox light by choosing differently colored metallic foil for the lining. A tip: Build two softboxes, one with gold colored lining for portraits and nature, and one with a silver lining for technical subjects.

▲ The size of the 4 side panels depends upon your needs, but the width in the back should be at least the same size as the flash.

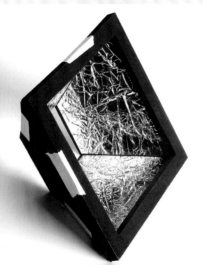

◀ Before gluing the materials, first test that all the individual pieces fit well together.

▶ Use instant glue for the seams.

▼ *Use two rectangular inserts to reduce the size of the opening, so that it is a little smaller than the outer diameter of the flash. Because EVA foam is very elastic, the softbox will hold onto the flash without any problems.*

▼▼ *Glue the diffuser foil from the back onto the frontal frame, and then attach the frame to the body of the softbox.*

The side panels of the angular softbox consist of 3/16" (4 mm) thick EVA foam, while the front frame and the backside are each 5/16" (8 mm) thick. Draw the shapes of all the pieces on to the EVA foam before beginning cutting. The width of the back panel is dictated by the size of the flash, and the front frame depends on the depth of the box. Be sure to make precise angle measurements, so that all pieces will fit together properly. After cutting the individual pieces and testing that they fit together, you can line the inside with silver or gold colored metallic foil. Now you can begin the assembly. Pay attention to the precise alignment of the edges. Before gluing the diffuser panel on to the front, check one more time that the back will still fit on to the flash unit. It should have a snug fit, but the back panel should not deform significantly. Extra glue can be removed with a fine grade sand paper without damaging the matte surface of the foam.

MATERIALS:
- EVA foam sheets, 4 mm and 8 mm thick
- Black rubber hose
- Mylar or backlit film
- Emergency blanket or colored foil

TOOLS:
- Utility knife
- Metal ruler
- Instant glue
- Spray glue
- Sand paper
- Tape

SOURCES FOR MATERIALS:
- Art or drafting supply store (Plexiglass)
- Craft store (EVA foam)

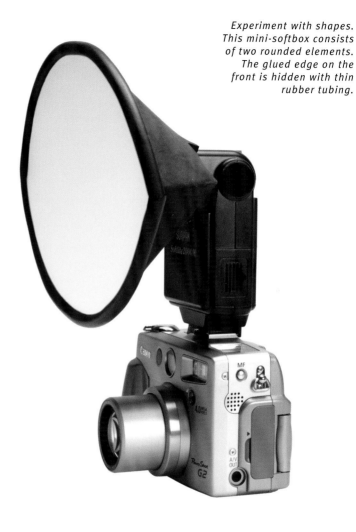

Experiment with shapes. This mini-softbox consists of two rounded elements. The glued edge on the front is hidden with thin rubber tubing.

▲ *Using a round bowl or lid as a guide helps in cutting rounded shapes.*

Design individual shapes for your softboxes. In addition to square shaped softboxes, elongated (for small light edges) and oval shapes can easily be created. Let your creativity run wild.

▲ Image with normal flash lighting: The shadows appear distracting and completely unnatural. In short – the image failed.

▲ Mini-softbox lined with silver colored foil: This is a small box with a big effect. The image shows an even illumination with natural shadows.

▼ Image with normal flash lighting: The detail is lost in the dark shadows due to the harshness of the direct flash. The resulting color seems too cool.

▼ Mini-softbox lined with gold colored foil: The softer, warmer light gives this image an appealing, natural character.

Closeup Diffuser

It only takes a few minutes to build this special diffuser for closeup photography. The only requirement for attaching it to your camera is that your lens has to have a filter thread. Depending on the type of camera, you can attach it either directly to the lens or by means of a filter adapter. The closeup diffuser scatters the light, resulting in much softer shadows. But above all, it is attached to the lens and thus follows all camera movements.

The internal flash of most compact cameras light the diffuser perfectly, because they lie just outside the optical axis and are generally constructed to illuminate straight ahead. This is different for single-lens reflex cameras, in which the internal flash is flipped up and usually illuminates directly above the diffuser. In these cases, it is better to use a hot-shoe flash with a flash bounce shoe adapter.

Soft light for closeup images with flash. It is like a small light tent that can be screwed on to your camera lens.

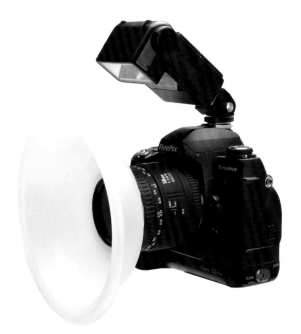

MATERIALS:
- White plastic bowl
- Old/used filter or filter adapter

TOOLS:
- Compass cutter
- Instant glue

SOURCES FOR MATERIALS:
- Thrift store
- Photography store – used equipment department

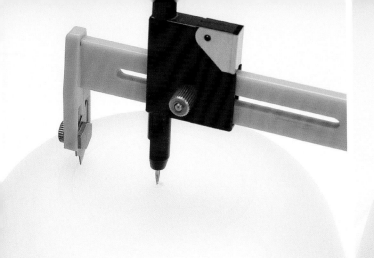

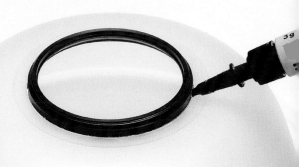

▲ Avoid cutting the circle too large; if necessary, it is easy to enlarge it by removing excess material with fine grade sand paper. Neutral lens protection

filters such as skylight and UV-filters make great adapters, as do step-up rings. These can be purchased from a camera store to fit the filter thread of your lens.

▲ Attach the filter to the bowl with a few drops of instant glue, but make sure that the glue does not run into the filter thread.

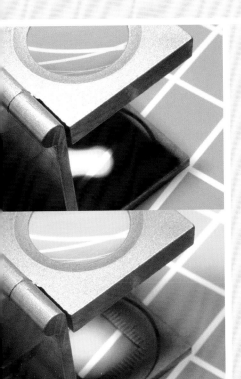

◄► Without closeup diffuser: harsh shadows and high contrast.

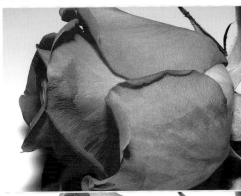

◄► With closeup diffuser: significantly lighter and softer shadows; the background is also more evenly illuminated.

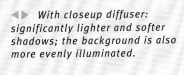

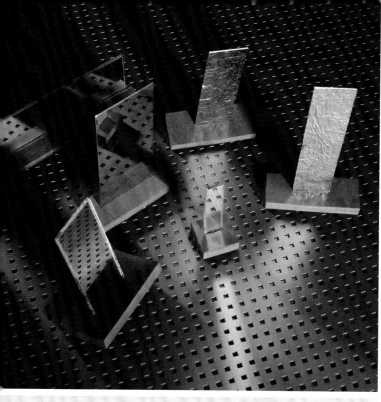

▼ *An interesting play of light and shadow is created by means of hard side lighting and the use of several small mirrors.*

▲ *Small brightening devices help direct the light specifically to the right spot and influence its color – be it small mirrors, polished metal, silver or gold colored foil, or white or colored cardboard.*

Brightening Devices
and Mirrors

Usually, a modeling light is needed to set up an effective direction of light with the use of mirrors and other brightening devices. However, if you work with conventional compact flash units this option is not available. Setting up a normal lamp where the flash is located will help you to determine correct placement of the mirrors. When you are ready to take the picture, just exchange the lamp with the flash. Of course, this procedure is only an aid, as the final placement of the mirrors must be checked with test shots, and corrected, if necessary. The exact placement of the brightening devices is easiest with holders made of EVA foam. Alternatively, you can use modeling clay. An old gooseneck lamp can be reworked to hold mirrors or similar items above the subject to be photographed.

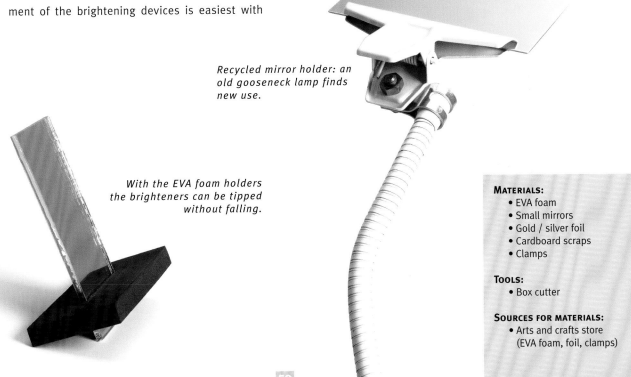

Recycled mirror holder: an old gooseneck lamp finds new use.

With the EVA foam holders the brighteners can be tipped without falling.

MATERIALS:
- EVA foam
- Small mirrors
- Gold / silver foil
- Cardboard scraps
- Clamps

TOOLS:
- Box cutter

SOURCES FOR MATERIALS:
- Arts and crafts store (EVA foam, foil, clamps)

▲ *Common flashlights can be used as light brushes.*

No-Budget Light Brush

Due to its variable beam of light, a normal flashlight can be used as a special effect light or "light brush" in places where precise lighting is necessary. The incandescent light bulb bathes the subject in a yellowish light, which can create interesting moods and can imitate sunlight. In contrast, the common LED lights produce a white or colorful light. To use a flashlight effectively, you need longer shutter speeds, during which you can precisely illuminate the subject. Therefore, a tripod is a must. If you work in the studio, you can simply darken the room, whereas outside you are dependent on evening and nighttime.

The natural lighting shortly before sunset arguably offers the most interesting lighting character. The creative options are further expanded when combined with a manually triggered flash and colored foil. However, such images require careful planning, and above all a lot of practice.

▼ *With a bare light bulb you can emphasize fine details.*

▼ *Lighting moods such as this one can only be achieved with a light brush. Ideal shutter speeds range from 10 to 20 seconds.*

MATERIALS:
- Flashlight
- Spare batteries or rechargeable batteries
- Tripod

Going Shopping

A large portion of the time to create this book has been spent in researching materials. The question of who can deliver what, when, and especially in which quantities, is an art in itself. Here is a small overview of interesting shopping opportunities, so you will not lose all the fun on your do-it-yourself project while endlessly searching for the materials.

Home Improvement Stores
Tools, metal rods, glass shelf brackets (or through TechnologyLK), glue gun, emergency blanket, insulation mats, acrylic glass (or through rplastics.com)

Hardware Store
Fittings for metal rods

Kite Building Supply Store
Ripstop nylon, fiberglass rods, fittings, all the things that need to be lightweight, yet strong

Office Supply Stores, Arts and Crafts Stores, and Graphic or Drafting Supply Shops
EVA foam, spray glue, instant glue, cardboard, papers, presentation boards, velour paper, cutting mats, metal and French curve rulers, utility knifes, artificial plants, backgrounds, Mylar or backlit film, etc.

Outdoor Sports Shops
Insulation mats (the alternative to polyethylene and EVA foam)

Stage Lighting Stores
Neutral density filter foil, microphone stands

Camera Stores
Especially in the second hand sections of camera stores, you can find tripod mount screws, adapters, filter foils, flash slaves, flash bounce shoe adapters, cable releases, and much more

Internet Auctions
Used flash units for your home studio; generally you find everything here you don't find elsewhere – but patience is required

Search Engines
Because the Internet changes constantly, search engines are very helpful in locating affordable shopping opportunities

Have fun shopping!